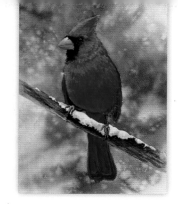

# Watercolor Basics

Watercolor—the ultimate painting medium—takes only a few minutes to learn but a lifetime to master. I fell in love the first time I saw the rush of color on wet paper. After thirty years of painting, I still find it fun, exciting, and completely suited to my every art need, from quick, loose studies to photorealistic masterpieces. What watercolor *isn't* is boring. Some days it seems to have a mind of its own, producing unexpected but fresh and entirely pleasing effects. It's learning to work with these happy accidents that helps bring your inner artist out to play. Whether you're a master painter or an absolute beginner, watercolor is the perfect partner for your painting pleasure. —*Deb Watson*

## CONTENTS

# TOOLS & MATERIALS

Before you begin painting, it's a good idea to acquire a few basic tools that will make your foray into watercolor artistry easier and more enjoyable. Specialty options are abundant, but the following introductory materials will get you off to a promising start.

## PAINTS

Watercolor paints are available in cakes, pans, and tubes. It's always best to use good-quality paint, but if you are just starting out, it's okay to use less expensive student-grade paint and upgrade to professional grade later. You don't need to have a huge palette of colors; each project in this book lists the specific colors you will need.

## MASKING FLUID

Masking fluid, or liquid frisket, is a latex-based substance that can be applied over areas you want to keep white. When dry, the mask repels paint, so you can paint over it without staining the white support underneath. When the paint is dry, gently rub off the mask with masking fluid pickup or an old rag. You can also apply masking fluid over color that is already dry to protect it from subsequent layers of paint.

## BRUSHES

A wide range of brush types and sizes is available. Brushes come in three basic hair types: soft natural-hair, soft synthetic-hair, and bristle brushes. Synthetic brushes work well with masking fluid; however, they don't retain as much water, so you may find natural-hair brushes easier to use with paint.

Flat Brush

Round Brush

Liner Brush

Hake Brush

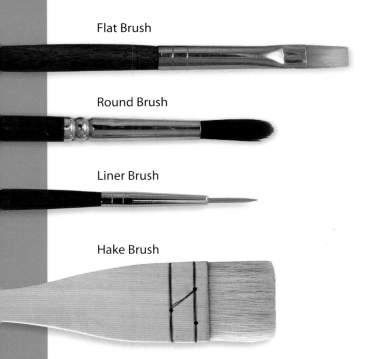

### BRUSH SHAPES

**Flat brushes** are ideal for creating straight edges and strokes of uniform width. Their heads vary in length; the longer the hairs or bristles, the longer you can stroke without reloading the brush.

**Round brushes** taper to a soft point, allowing for varying stroke widths. They hold lots of moisture and don't need to be reloaded with paint as often.

**Liner brushes** have only a few long, soft hairs, making them perfect for fine lines and details.

**Hake brushes** have short, soft hairs and a wide base. These brushes create bold strokes with rough trails and are ideal for laying in washes.

# PAPER

Watercolor paper comes in a range of textures: hot-pressed, which is smooth; cold-pressed, which has a medium texture; and rough, which has plenty of tooth (raised areas of paper). Watercolor paper also comes in different weights, designated in pounds. The higher the number, the heavier the paper and the less likely it is to warp when you apply water. The sturdy surface of 300-lb. bright white, cold-pressed watercolor paper allows you to use masking fluid, as well as some lifting techniques, without damaging the paper. Additionally, the weight of 300-lb. paper allows for a wider time frame to work wet-on-wet before the paper begins to dry.

**Watercolor Paper** These three different sheets show how watercolor paint looks on rough, textured paper (A), cold-pressed paper (B), and hot-pressed paper (C).

# PALETTES

The fluid nature of watercolor and gouache painting calls for palettes with wells for containing mixes. Rectangular wells are often slanted for better pooling. White plastic palettes are an economical choice for watercolor, as they are lightweight and easy to clean; the white also allows artists to judge their paint colors as they will appear on white paper. Some artists opt for uncoated aluminum palettes, which offer a bright, reflective surface that is durable, resistant to rust, and easy to clean. Many watercolorists use white porcelain palettes; these heavier dishes are sturdy and resist beading on the surface.

☐ Spray bottle (for rewetting paint and keeping watercolors moist)

☐ Artist tape & clips (to secure paper to a painting board or tabletop)

☐ Rags & paper towels (for cleanup and correcting mistakes)

☐ Sponges (to create washes or add mottled texture)

☐ White ink or gouache (for touch-ups and highlights)

# CREATING THE ILLUSION OF DEPTH

You can add depth to a flat painting by changing value, color temperature, color saturation, and softening edges.

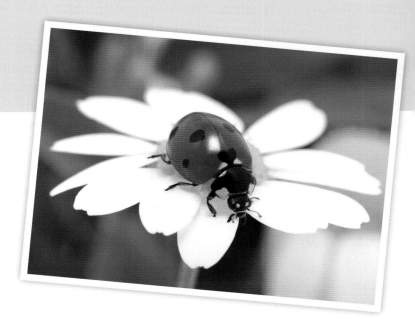

**Color Palette**

| cerulean blue | cobalt turquoise | lemon yellow |
|---|---|---|

| permanent rose | phthalo blue | white ink |
|---|---|---|

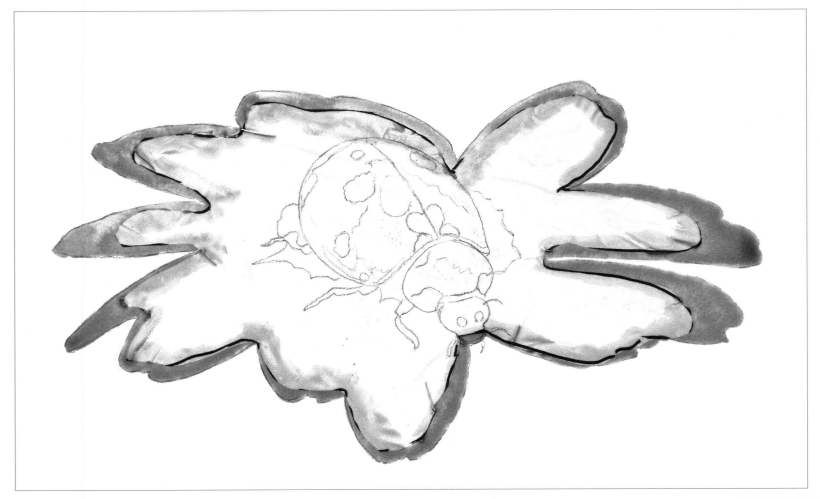

**1.** Sketch the ladybug and flower onto watercolor paper. Then trace the outline of the flower onto a piece of frisket film. Cut the frisket slightly smaller than the subject, and lay it on top. Paint liquid frisket around the film, covering and sealing the edges. Using frisket film to mask a large area is less damaging to the paper than masking fluid and won't lift the pencil drawing. If you choose to use masking fluid over the entire flower, draw the ladybug after the masking is removed in step 3.

### ARTIST'S TIP

Liquid frisket (also called masking fluid) and frisket film can be used to protect and preserve the white of the paper.

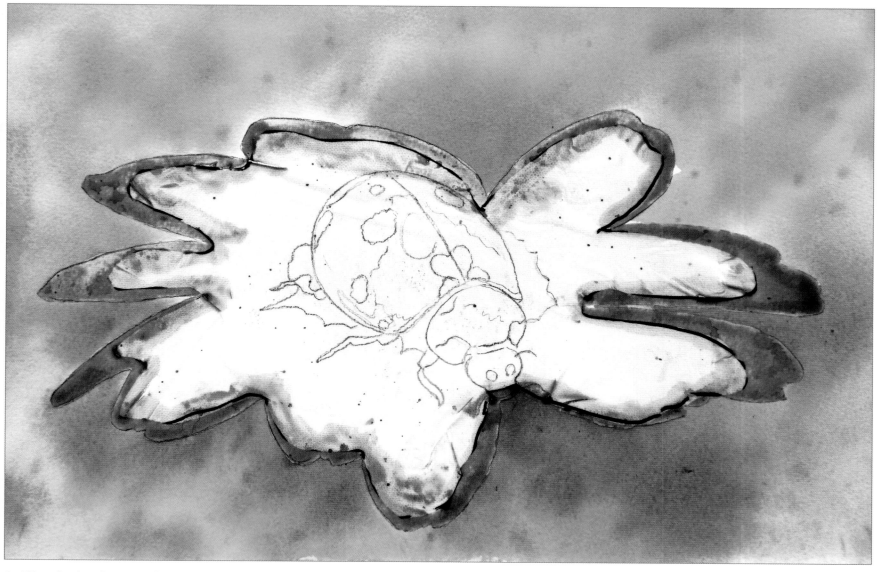

**2.** Wet the background, and drop in spots of yellow, allowing the color to spread. Next drop in a mixture of light green, yellow, and cobalt turquoise in several spots and a darker green mix of yellow and phthalo blue in a few spots on the lower half. Gradually darkening and intensifying the color toward the bottom half of the painting creates the illusion that the front of the subject is closer than the back. As the wash dries, spatter it with rose droplets by tapping your finger against a small loaded brush.

**1.** Apply the masking fluid to the desired areas of your paper using an old paintbrush (small rounds work well).

**2.** Eliminate bubbles, which may allow paint to reach the paper. Once dry, paint over the mask.

**3.** Allow the paint to dry, and then rub away the mask with a clean finger or rubber cement pickup eraser.

**4.** The mask will leave behind clean, crisply preserved areas of white paper.

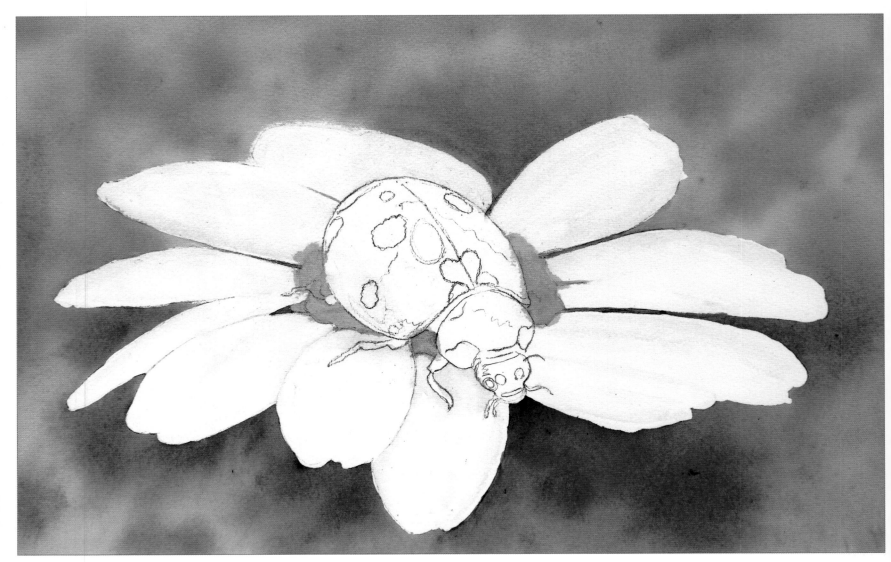

**3.** When the background is dry, peel off the frisket. Use the darker green mixture from step 2 to paint the tiny lines between the background petals. Then paint the yellow center. Use a very diluted wash of cerulean blue to paint the back petals and lines in the foreground petals, as well as to suggest a shadow under the ladybug. The subtle tint of cool color makes the back petals appear farther away, even though they're still nearly white.

---

### ARTIST'S TIP

Using multiple layers of color creates shadows and soft highlights
that result in a more realistic ladybug.

---

**Warm Red**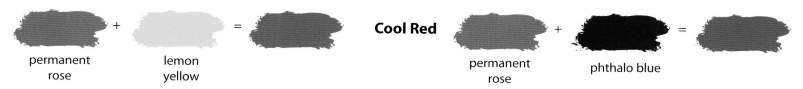

permanent rose     lemon yellow     **Cool Red**     permanent rose     phthalo blue

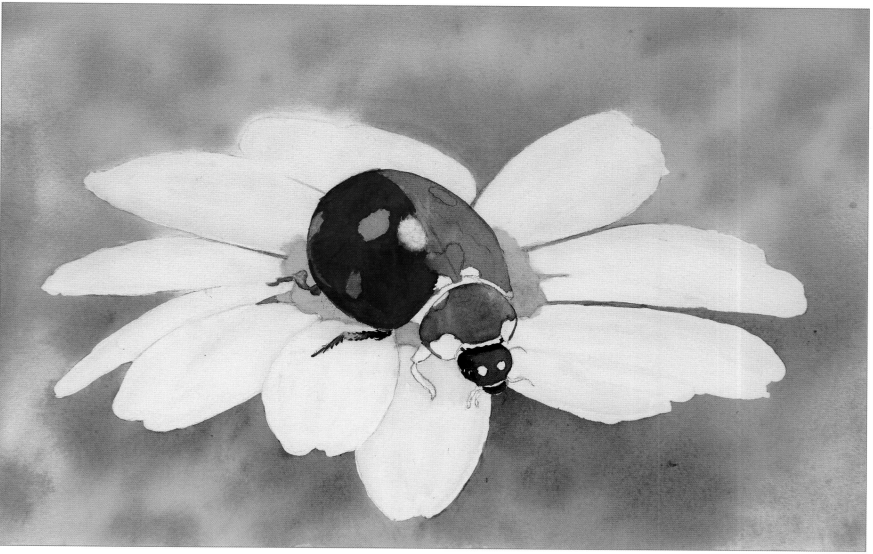

**4.** Mix rose and yellow for a warm red and rose with a touch of phthalo blue for a cool red. Graduating from warm red at the back to cool red about halfway forward, paint an initial light wash over the ladybug, covering everything but the white highlight. Once dry, apply a second darker wash, this time leaving the areas for the black spots unpainted. Create a black mixture with phthalo blue, rose, and a bit of yellow, and apply a light wash over the head. Paint the legs black, except for the areas of yellow pollen.

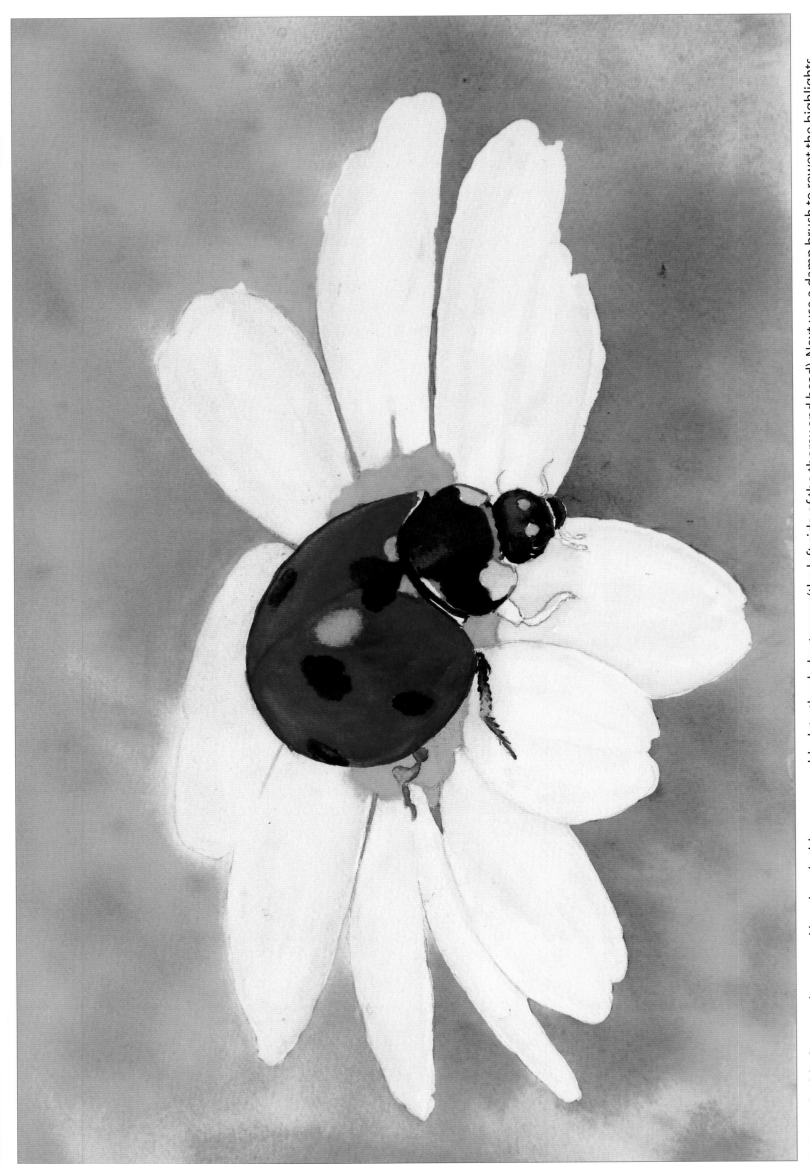

**5.** Paint the black spots, thorax, and head, and add even more black to the darkest areas (the left side of the thorax and head). Next use a damp brush to rewet the highlights in the black areas, dabbing with a paper towel to lift color. Tone down the white areas of the ladybug with a diluted wash of cerulean blue and black. Then use a purple-red mix around the edges of the ladybug and for the line dividing its wings.

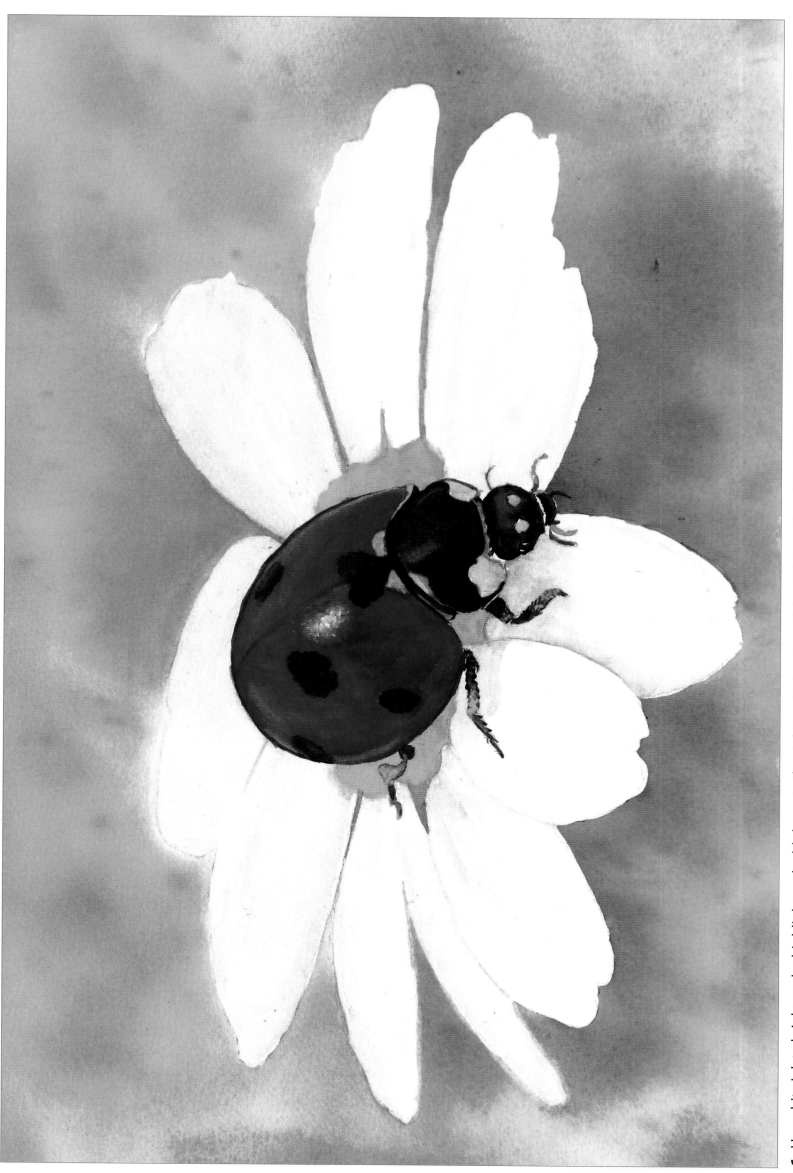

**6.** Use white ink to brighten the highlight and add sheen to the right and left edges of the ladybug. Then finish the legs and antennae. With the cerulean blue and black mix, paint the shadow under the ladybug and the overlapped petal in front. To finish, soften the edges of the white petals in the background with a damp brush. Rewetting the area slightly, lift color by rubbing with a paper towel. Leaving hard edges in the foreground and creating soft edges in the background helps mimic reality.

# EVOKING MOOD

Evoking a specific mood in a painting requires careful choice of color and form. To enhance the feeling of calm and wonder in this beautiful snow scene, we'll simplify the details.

**Color Palette**

| cerulean blue | lemon yellow | permanent rose | phthalo blue | ultramarine blue | white ink |

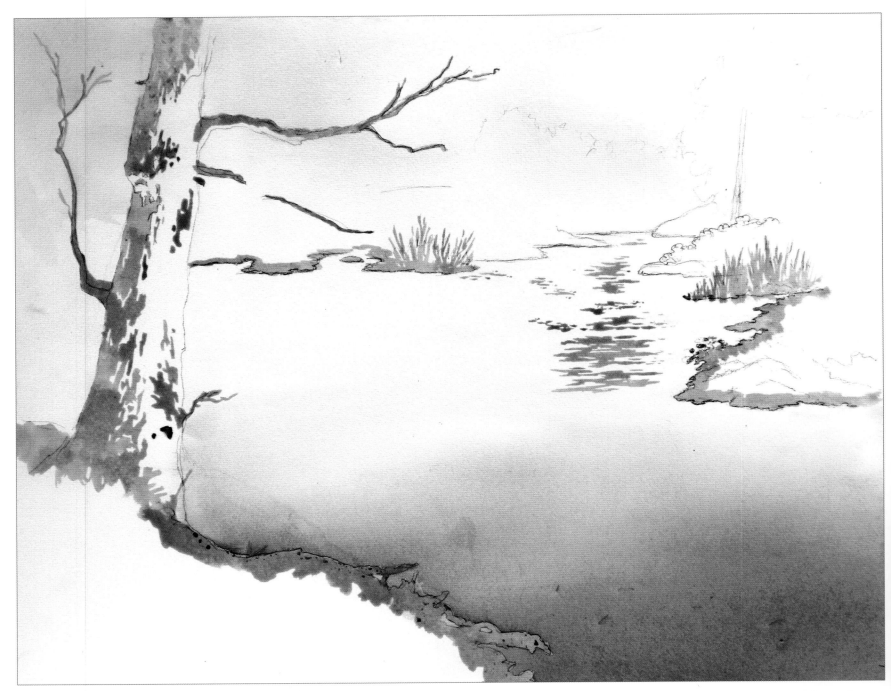

**1.** Draw the outline of the scene. Then mask the snow and highlights on the water. Next wet the paper and paint a mix of cerulean and ultramarine blue on the lower third of the water. Working wet-into-wet yields soft edges that contribute to the scene's serene mood. Add a hint of the blue mixture to the top of the sky, and drop in watery rose around the distant tree line. Adding hints of a warm color to a primarily cool painting makes the scene feel more inviting.

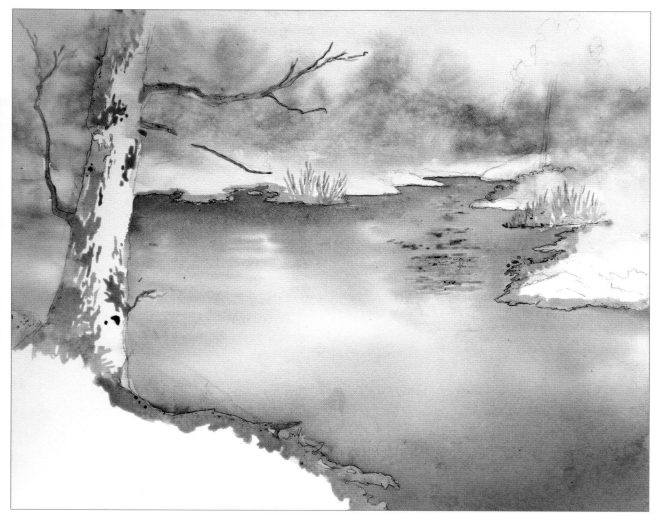

**2.** Wet the background snow, and drop in cerulean blue, cerulean blue mixed with rose, and cerulean blue mixed with rose and a bit of yellow. To achieve the look of distant trees shrouded in mist, let the dropped-in colors create a soft, nebulous mass of vague tree shapes. Then spatter clean water into the mass to create more mottling. Once dry, rewet the water and paint the same colors, tilting the paper to let the colors mix and form reflections of the tree masses.

**3.** Paint the middle-ground trees with the same mixes from step 2. Rewet the area, and paint slightly thicker masses, creating one tree on the right and a larger tree mass on the left. Then add soft shadows on the snow. When dry, suggest tree trunks peeking out, as well as two bare trees. Rewet the water, and paint the middle-ground reflections with the same colors.

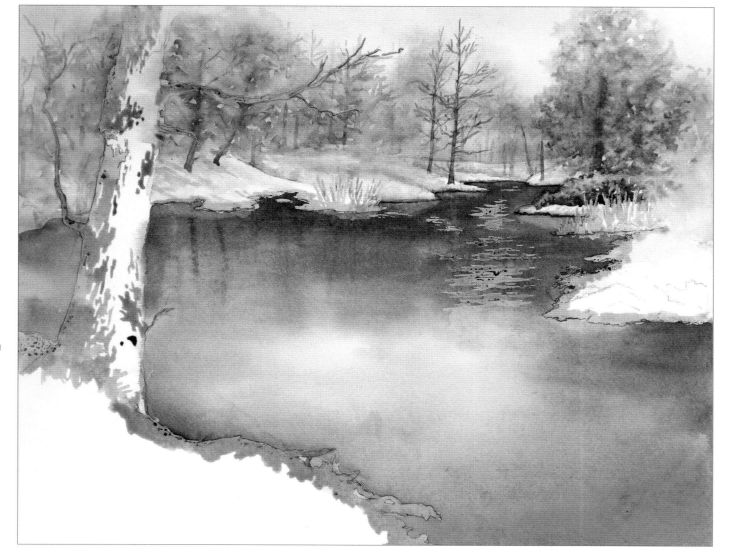

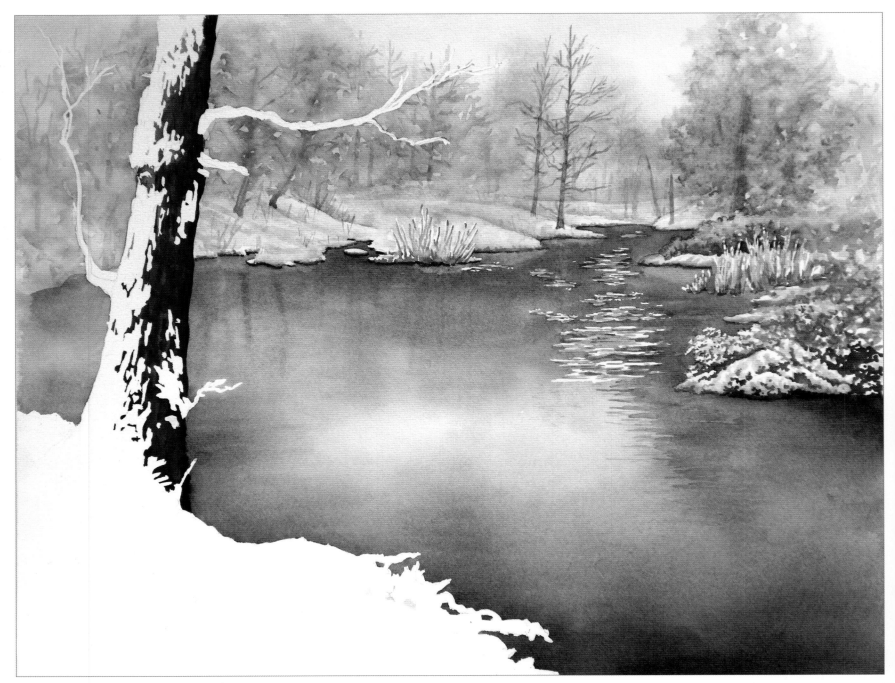

**4.** Mix phthalo blue, rose, and yellow to make a dark purple-brown, and paint the foreground tree. Again rewet the water, and apply another layer of cerulean blue to the foreground, adding the purple-brown mixture near the bottom edges. Once dry, remove all the masking and use a soft, damp brush to rub and soften any hard edges. With the dark mix of color, paint shadows at the bottom edges of the distant snow on the river. Use the same dark mix and other colors to finish the details of the snowy area on the left.

### ARTIST'S TIP

Use colors that match the lines of your paintings, such as blue with soft curves for serenity or yellow with bouncy lines for joy. The power of mood will elevate your painting to an entirely new level.

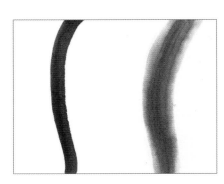

**Soft & Hard Lines**
Any line can be softened by blending the edges with water.

**5.** Using a light-gray mix of cerulean blue, rose, and yellow, paint the shadows on the snowbank and foreground tree. Use the dark mix to add a few sticks and crevices and white ink to suggest soft reflections in the water. For the softly falling snow, spatter white ink with an old toothbrush.

# ADDING INTEREST

People are fascinating subjects, but capturing human interest in a portrait requires a special approach that highlights the individual's unique characteristics. A dramatic background combined with playful bubbles adds interest galore to this portrait and accentuates the sweet innocence of childhood. There are so many easy ways to create a piece with character. With a little experimentation, your portraits will transform from ordinary to timeless!

**Color Palette**

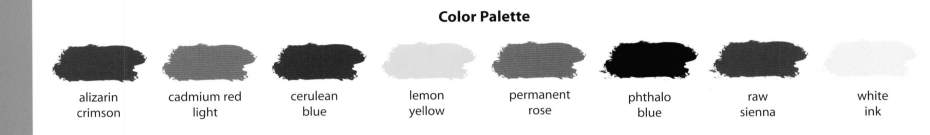

| alizarin crimson | cadmium red light | cerulean blue | lemon yellow | permanent rose | phthalo blue | raw sienna | white ink |

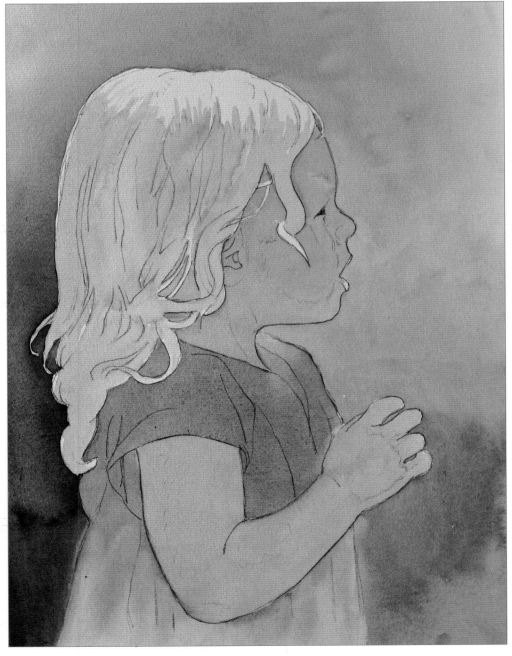

**1.** Make an initial pencil sketch on toned watercolor paper. Then paint a light wash over all areas. Use a light wash of yellow and skin color over the hair, leaving the highlight on the crown unpainted. Use a wash of cerulean blue and yellow for the dress. Mix cerulean blue with permanent rose to make purple, and gray it down with a touch of skin color for the background.

**Skin Tone**

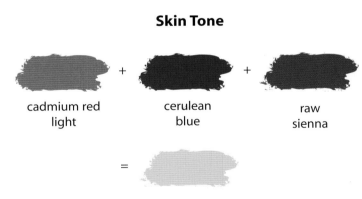

cadmium red light + cerulean blue + raw sienna

=

---

### ARTIST'S TIP

Using a complementary color (purple) to the yellow in the girl's hair makes her tresses appear even brighter.

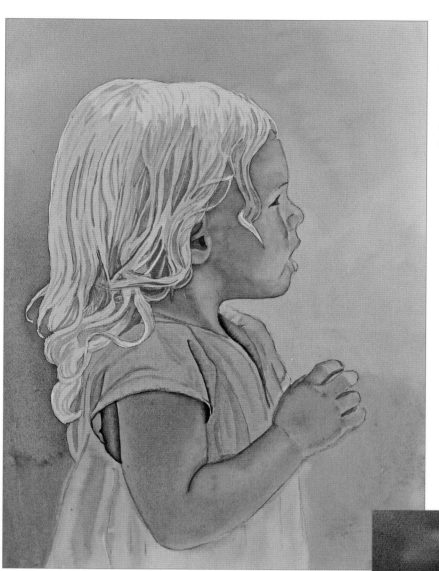

**2.** Rewet the face and arm, and layer on more of the skin-tone mix. With portraits, it's best to build up color and value with many washes, drying thoroughly between layers. Next mix skin color with yellow and paint between the strands of hair. Use more pigment to create darker skin tones for the shadows in the ear, the eye, and under the sleeve.

### ARTIST'S TIP

Using an opaque color like cadmium red in a skin-color mix helps the skin appear solid, even with just a watery wash of color.

**3.** Mix a dark purple using alizarin crimson and phthalo blue. Wet the background with clean water, and use a large brush to paint. Work quickly around the figure, avoiding the delicate lines of the face and hair. Then switch to a small brush and carefully paint the dark color right up to the face and hair. If the initial wash dries lighter than expected, repeat the process.

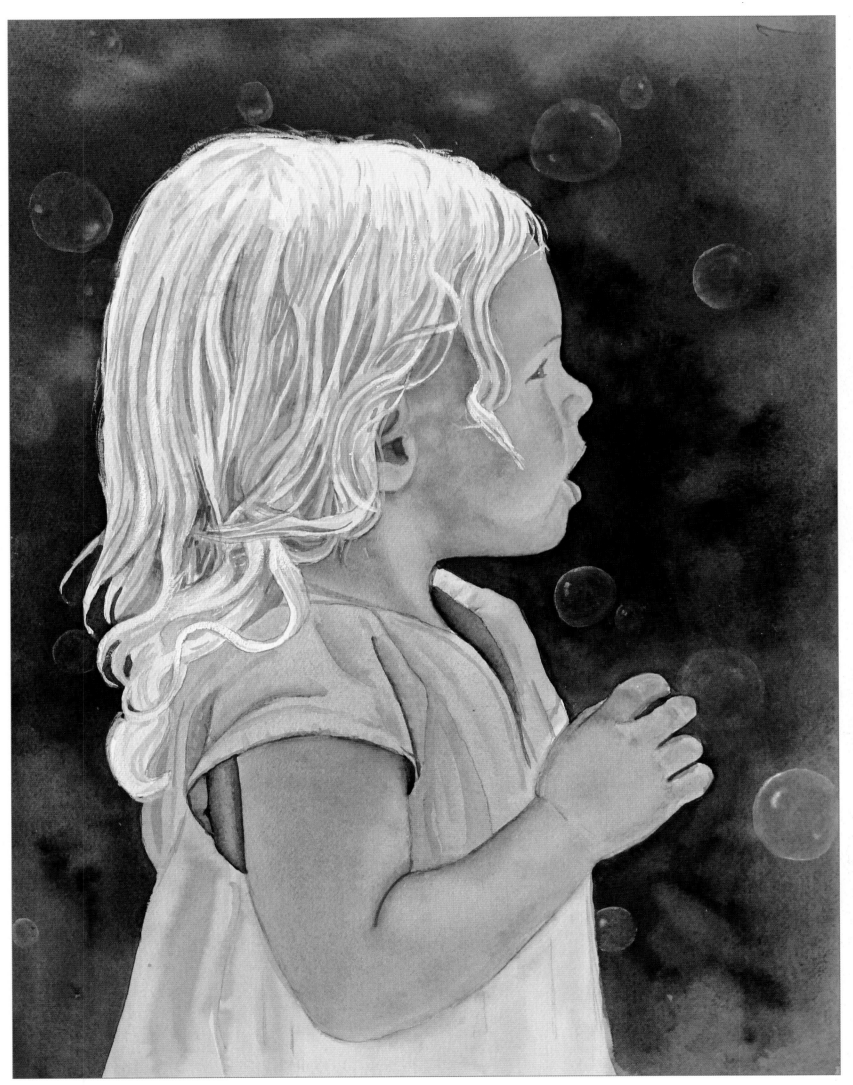

**4.** For the bubbles, paint circles of white and fill them with clean water so the white spreads into the centers. Then, after dabbing most of the white out of the centers with a paper towel, add a touch of white inside for a highlight. Varying the whiteness and size of the bubbles makes them appear to float and adds depth to the background. Use white to add hairs around the outside edges of the existing hair to soften its appearance and white highlights on select strands of hair.

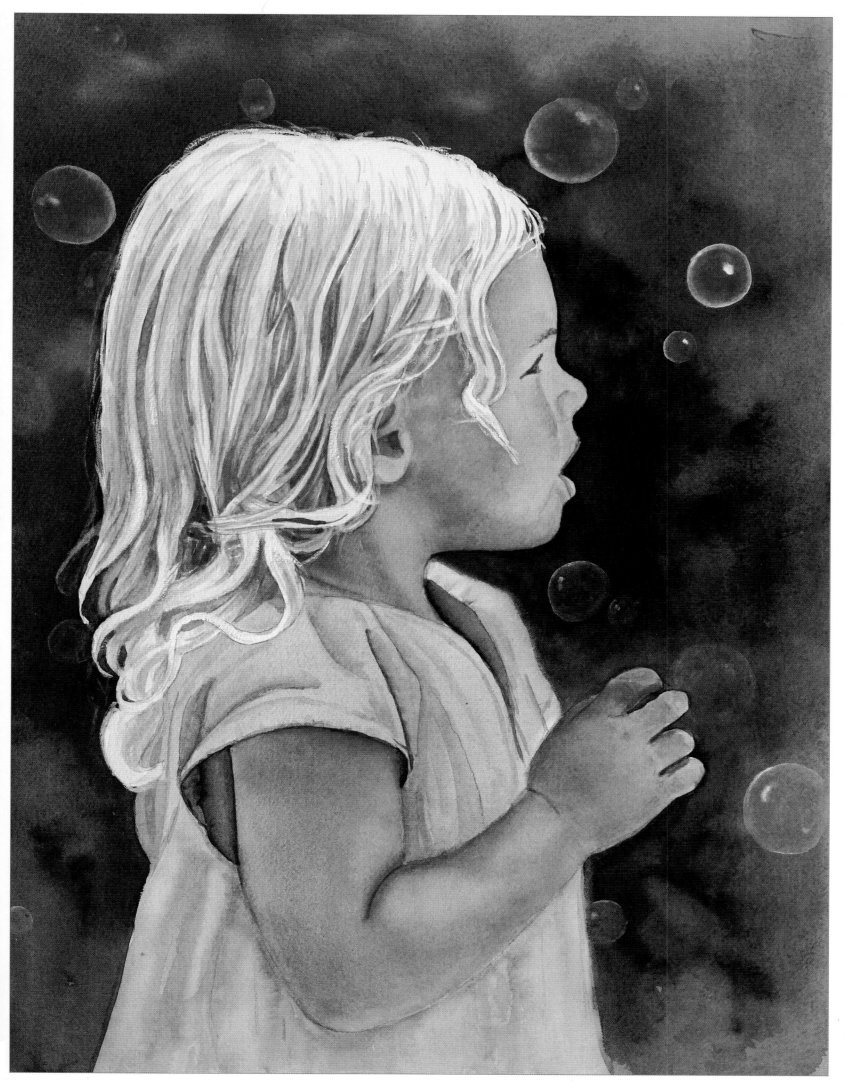

**5.** Add more color to the hair and to the shadows between strands, and darken the neck and arm shadows. Repaint a few bubbles to make them more distinct. Finally, add a watery wash of alizarin crimson all over the skin. This "pinks up" the skin in a pleasing way and helps smooth the transitions from light to dark.

# CREATING TEXTURE WITH SALT & MASKING

The prospect of painting fur can feel daunting, but don't let the challenge hold you back! Rather than paint thousands of tiny hairs, simply apply washes of color and let salt create the illusion of fur.

**Color Palette**

burnt sienna    cobalt blue    cobalt turquoise

lemon yellow    permanent rose    phthalo blue

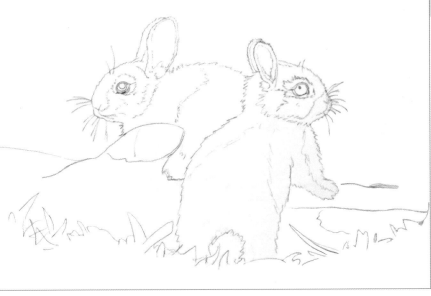

**1.** Use the initial drawing to mark the light and dark areas in the fur on the body, paying close attention to the detail on the face, particularly around the eyes.

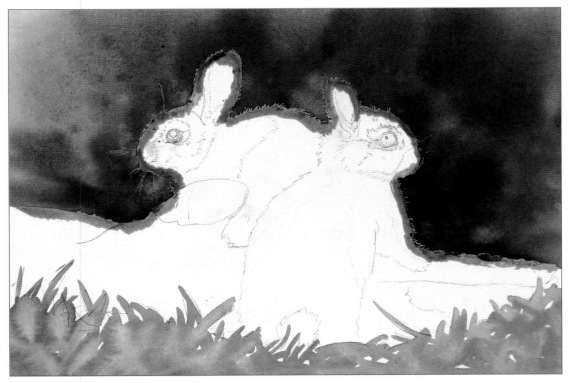

**2.** Mask the edge of the log and bunnies, and use a dental pick to pull fur and whisker lines out of the wet masking fluid. Evenly wet the background, and drop in lemon yellow, letting it spread. Mix different shades of green (yellow + turquoise + phthalo blue + burnt sienna), and drop them in, tilting the paper to let the water and gravity blend the colors smoothly. Spatter yellow into the dark areas and a little green into the light areas. Then, working on dry paper, paint the grass. Paint clean water into the drying grass for texture.

**Tilting** To pull colors into each other, apply two washes side by side and tilt the paper while wet so one flows into the next. This creates interesting drips and irregular edges.

**Black Eye Mix**

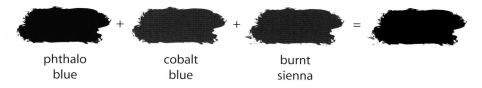

phthalo
blue
+
cobalt
blue
+
burnt
sienna
=

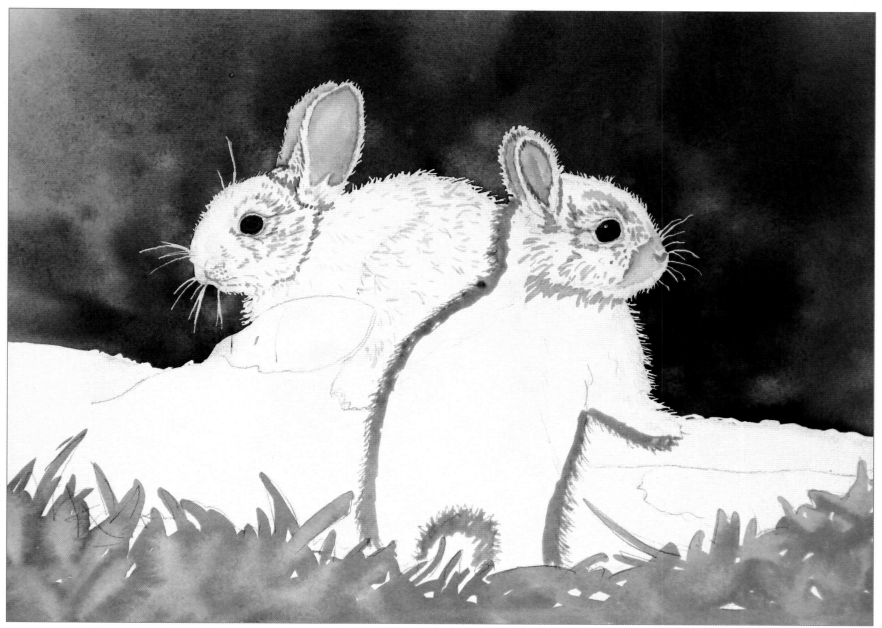

**3.** When the washes are dry, rub off the mask and apply another layer of masking fluid to the outside edges and tail of the foreground bunny. Paint each eye with a black mixture of phthalo blue, cobalt blue, and burnt sienna. Then paint the ears with a watery mix of rose and yellow. Use a small brush to draw darker lines on the face and ears of each bunny.

**Using Salt** For a mottled texture, sprinkle salt over a wet or damp wash. The salt absorbs the wash to reveal the white of the paper in interesting starlike shapes. The finer the salt crystals, the finer the resulting texture. For a similar but less dramatic effect, simply squirt a spray bottle of water over a damp wash.

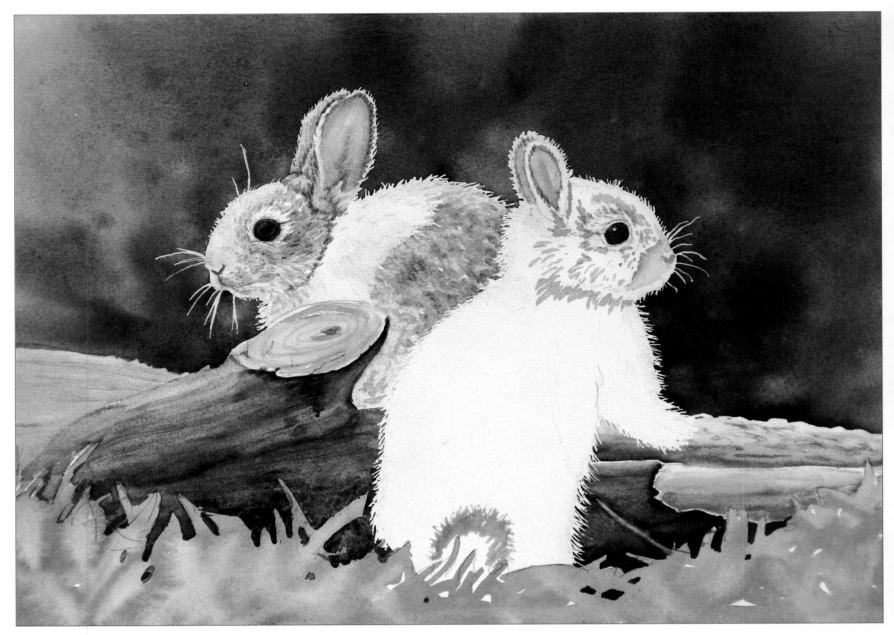

**4.** Paint the background bunny with a blue-gray mix of cobalt blue and burnt sienna, leaving the white areas. Sprinkle salt evenly over the wet area. After the salt sets for a minute, lightly apply short strokes of darker blue-gray over the salted area. Paint the nose pink, and add shadows to the ears. Then paint the wood with various mixtures of cobalt blue, burnt sienna, and yellow, carefully painting around the grass. Once dry, remove the masking from the edges of the foreground bunny, except for the tail.

The darker color spreads around the salt randomly, resulting in an organic, furry texture.

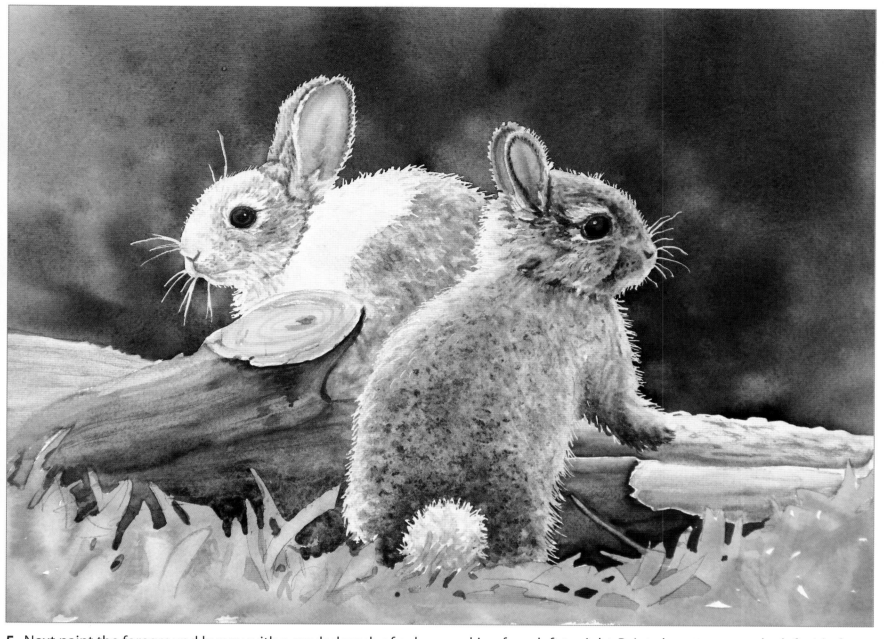

**5.** Next paint the foreground bunny with a graded wash of colors, working from left to right. Paint clean water on the left side for the highlight; light burnt sienna on the neck and upper back; and dark blue-gray on the lower back (darkest around the tail), which blends into clean water on the right side. Sprinkle the body with salt, let it set briefly, and work back into the salt with dark gray strokes. After the body dries, paint the head with the same colors. Then remove the masking from the tail and use light gray to suggest fur.

In this wash, the dark gray clings to the salt, creating a speckled effect.

**6.** Finish the grass by painting the bottom edge darker green and sprinkling it with salt. Once dry, paint a few areas with more yellow. Soften the back edge of the tree trunk by rewetting it and dabbing it with a paper towel. Then blend the front and back of the trunk on the left side and add bark to the bottom right side. For a finishing touch, paint a few dark whiskers on each bunny's face.

### ARTIST'S TIP

Remove unwanted spots by rewetting them with clean water and wiping them away with a paper towel.

# Capturing Essential Details

Birds can stand on their own as captivating subjects, but they can also bring landscape and flower paintings to life by adding drama and movement. The trick is to familiarize yourself with the general anatomy of birds and study their nuances. Once you understand these essential details, you can convincingly capture a bird's essence.

**Color Palette**

alizarin crimson     lemon yellow     perylene green

phthalo blue     Winsor red

**1.** Make an initial sketch of the cardinal. To make the eye appear realistic and recessed, add a line of feathers below it to suggest a round cheek and an eyebrow above it.

**2.** Paint masking liquid around the sketch, and allow it to dry. Then wet the background with very light blue and drop in spots of perylene green, followed by three small spots of alizarin crimson. The colors spread on the wet surface, but sections of light blue show through. As the wash begins to dry, spatter it with clean water to add texture. Once dry, peel off the mask.

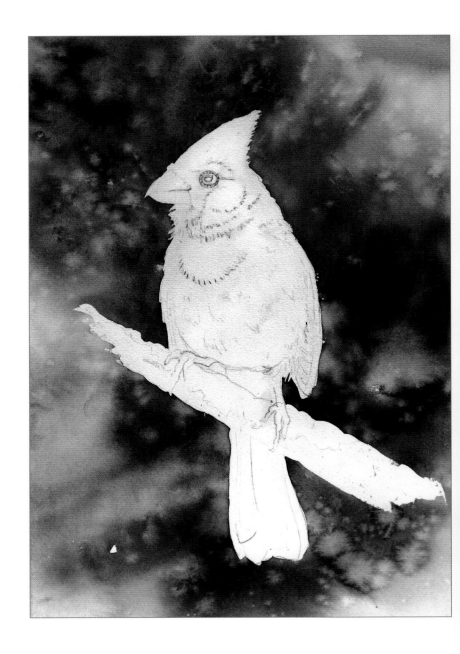

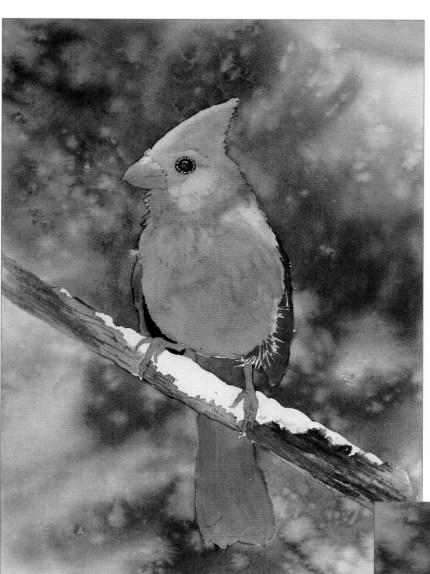

**3.** Apply a light wash of Winsor red on the cardinal's body. Paint the wings and tail darker, with alizarin crimson mixed with Winsor red. Leave the top of the bird's crest, cheek, and eyebrow lighter. Next paint the orange beak with a mix of yellow and Winsor red. Combine green and orange to make brown for the eye and tree limb. While the tree limb is still wet, scratch into the paper's surface to suggest the wood's texture. Mix blue and orange to produce a blue-gray color for the legs and the shadows on the tree limb.

**Beak Mix**

lemon          Winsor
yellow          red

**4.** Mix alizarin crimson with green, resulting in a warm black; then add blue to cool the mixture. Paint around the beak and eye, and then apply another layer of orange to the beak and add a brown line to separate the beak's top and bottom sections. Paint a small black pupil in the eye, leaving a white highlight. Add another layer of warm and cool red to the body. Use a damp brush to draw into the wet area and create soft, subtle feather patterns. Add suggestions of feathers with each wash, sometimes using small brushstrokes on dry paper, and other times painting water or a darker color into a wet wash.

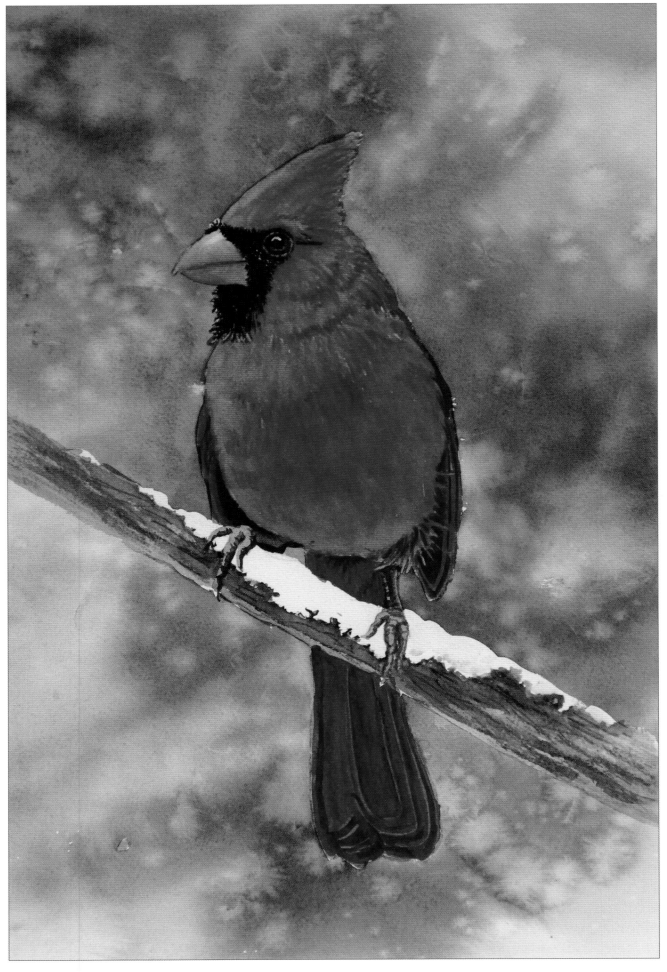

**5.** Apply another saturated wash of warm Winsor red over the cardinal. Then work a darker alizarin crimson into the center of the body. Use a dark mix of alizarin crimson and green to paint the tail feathers, leaving a line of lighter red between each to separate them. After using a cool black to create shadows around the toes and feet, add another layer of orange to the beak.

### ARTIST'S TIP

By capturing a bird's most prominent details—its eyes, beak, and the feather outlines that give its body form—you can make it appear as though it might soar off the paper. Start with a loose background, and layer color until you've created a fantastic feathered friend.

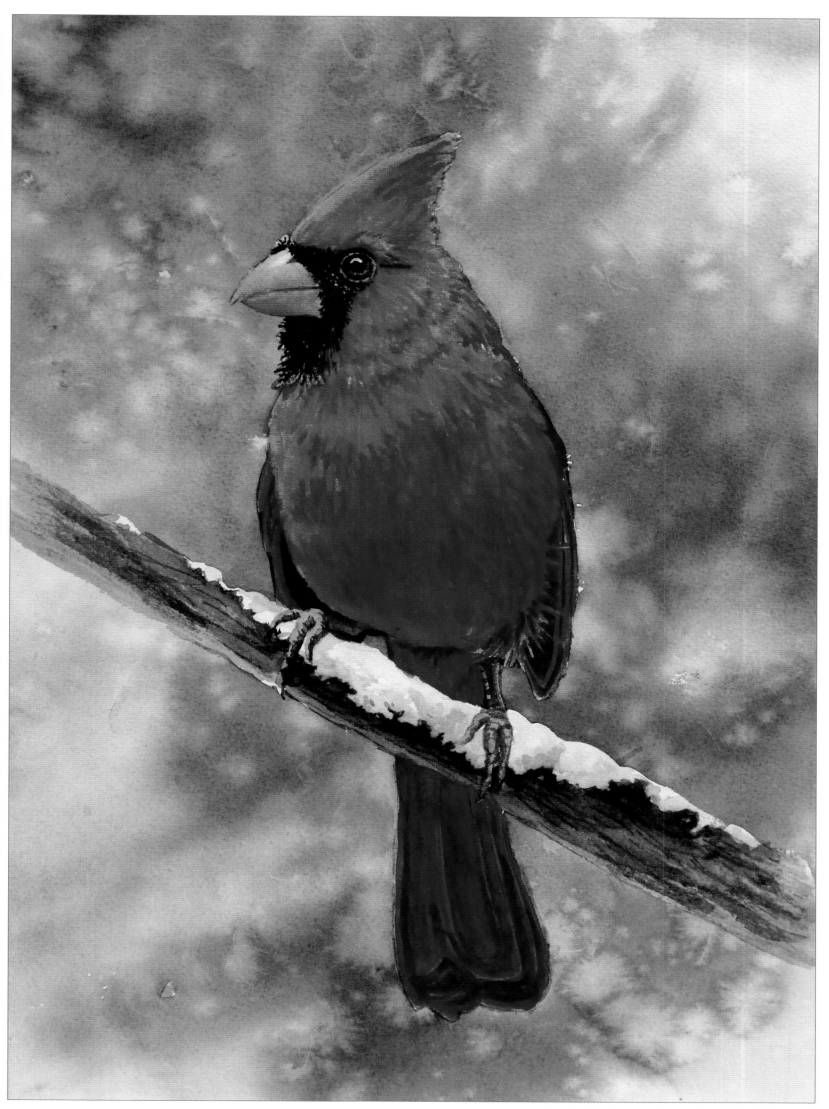

**6.** Paint one more layer of dark red in the middle of the body, and deepen the color of the wings and tail feathers. To give the tree limb a weathered look, add black just under the snow. Then mix black with blue to make a light gray mixture and add shadows near the base of the snow. Use a damp brush to smooth the dark line along the cardinal's crest, and dab the reactivated paint with a tissue to soften the line, creating a subtle glow.

# RENDERING SOFT EDGES

Flowers are one of the most exquisite subjects an artist can paint. With a little planning, you can transform any arrangement into a stunning work of art.

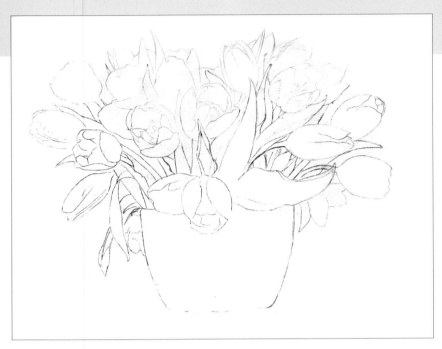

**Color Palette**

cerulean blue     lemon yellow     quinacridone rose     phthalo blue

**1.** I like to "audition" colors by painting samples onto scrap paper (see "Selecting Mixes"). Then I paint several quick studies using the chosen colors with different backgrounds (see below). Once you've selected your color palette, create a line drawing of the subject.

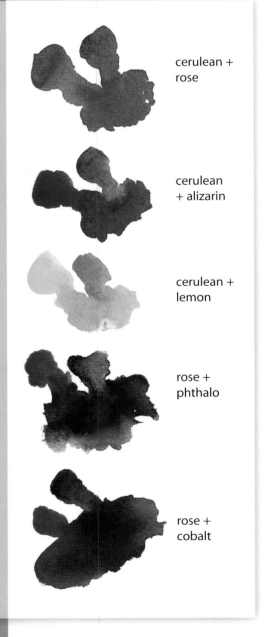

cerulean + rose

cerulean + alizarin

cerulean + lemon

rose + phthalo

rose + cobalt

### ARTIST'S TIP

Take a few minutes to work out the best composition, colors, and background. These templates will help you feel confident in achieving your finest work.

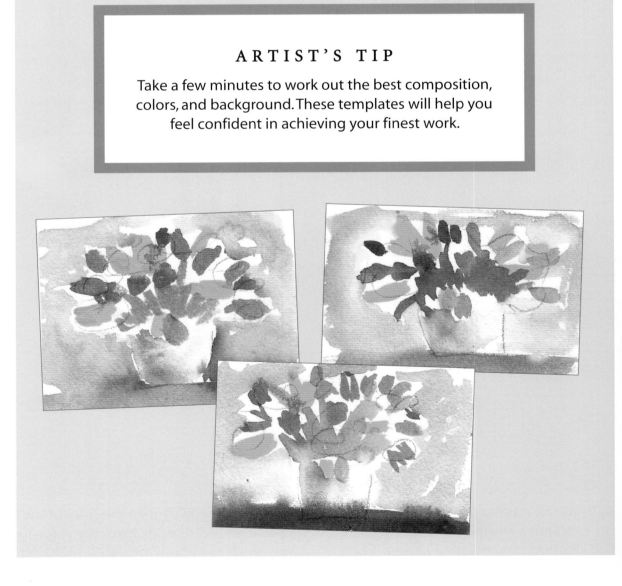

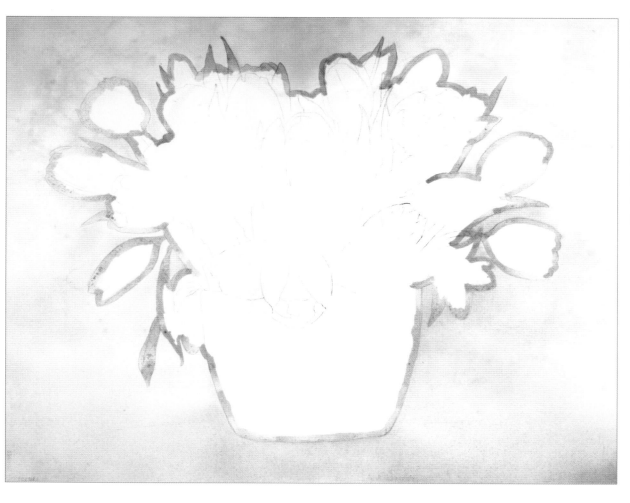

**2.** Paint masking fluid around the outer edges before wetting the entire background. Then drop in diluted colors—rose and yellow at the top, rose and cerulean blue on the right, and cerulean blue and yellow at the bottom. Mix the colors, and allow them to blend by tilting the painting. If an area begins to dry, mist it with a spray bottle. Then spatter yellow with a toothbrush.

---

### ARTIST'S TIP
Use a palette for mixing to avoid contaminating your colors.

---

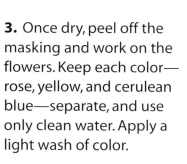**3.** Once dry, peel off the masking and work on the flowers. Keep each color— rose, yellow, and cerulean blue—separate, and use only clean water. Apply a light wash of color.

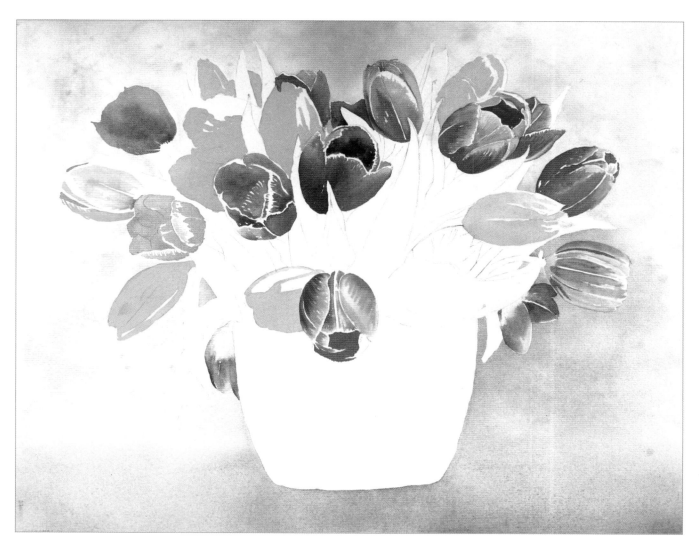

ARTIST'S TIP

Eliminate hard edges on flowers and leaves by rewetting the hard edge with the tip of a
small brush and then dabbing it with a paper towel to soften.

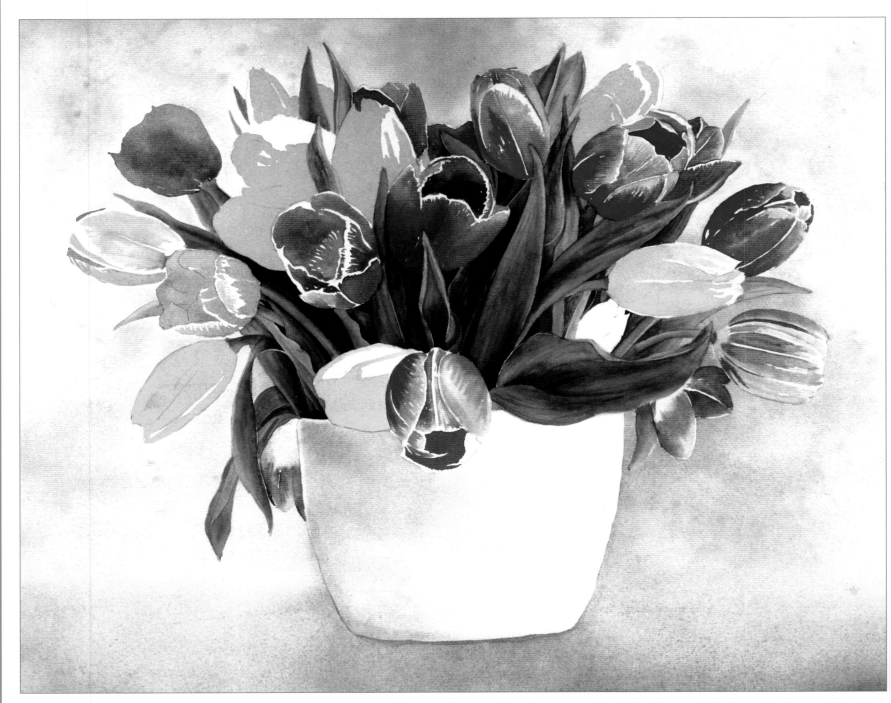

**4.** Wet the entire vase with clean water, drop in cerulean blue and a purple mixture on the left side, and tilt the painting to blend. After the vase area is dry, use a light green wash made from both the blues and yellow to cover the leaves. Mixing phthalo blue, yellow, and a bit of rose in varying proportions will create every shade of green needed for the leaves. Beginning with the shadowed areas, paint one leaf at a time. Work on dry paper, and paint the shadows with graded washes to achieve soft dark-to-light transitions.

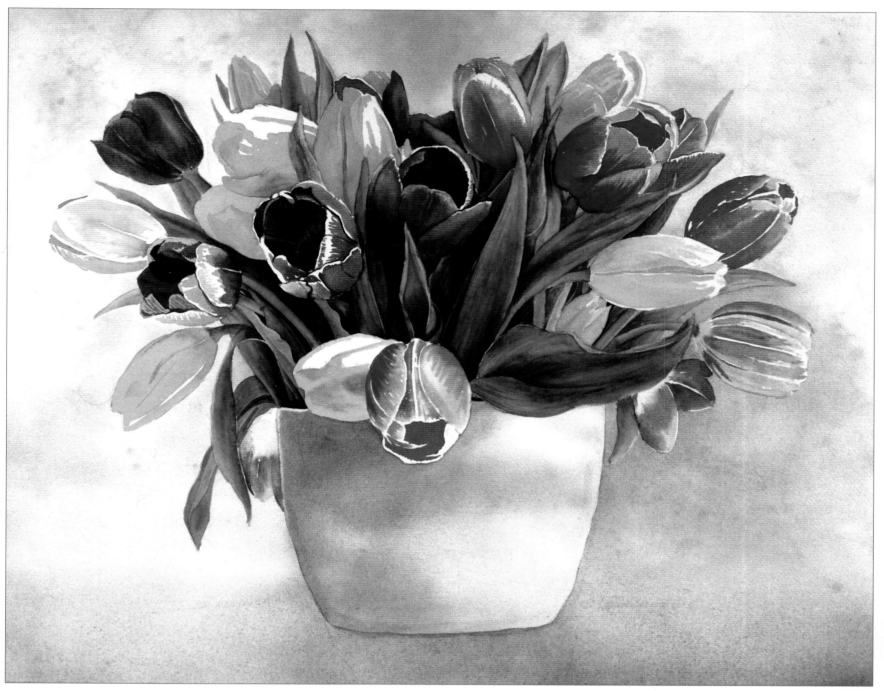

**5.** Give the vase another wash of cerulean blue and purple, again working wet-into-wet. Now finish the flowers. Work the values so that light flower edges are against dark leaves and dark flower edges are against light colors to create maximum visual impact. Keep your colors bright and pure by layering shadow colors and never mixing more than two primary colors at a time. For example, layer yellow tulip shadows with light washes of rose and yellow (orange), rose and cerulean (purple), or yellow and cerulean (green).

**Gradated Wash** A gradated (or graduated) wash moves slowly from dark to light. Apply a strong wash of color and stroke in horizontal bands as you move away, adding water to successive strokes.

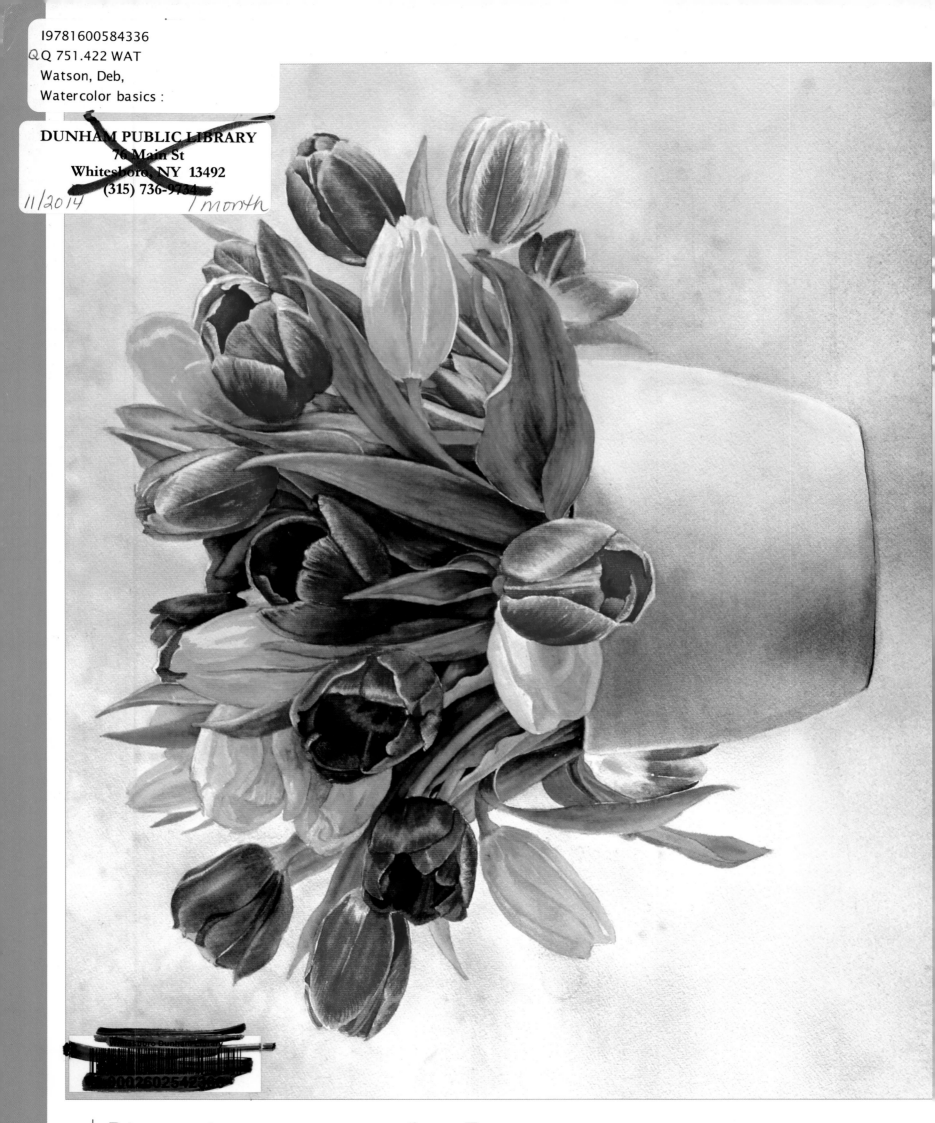

**6.** Wet the vase again before dropping in a final layer of blue and purple. Once dry, paint a small shadow under the edge (darker on the left side) so the vase doesn't appear to be floating. Use white ink to clean up ragged edges and add tiny highlights to a few leaf and flower edges.